Snapshot
of a Soul Place
in the land of special needs

WRITTEN AND ILLUSTRATED BY

Kari Burk

EDITED AND CURATED BY

Valerie Hennell

Published by Grand PooBah Music Publishing
58 Pirates Lane
Nanaimo, BC
V9R 6R1
www.snapshotofasoulplace.com

Library and Archives Canada Cataloguing in Publication

Burk, Kari, author
 Snapshot of a soul place in the land of special needs / written and
 illustrated by Kari Burk ; edited and curated by Valerie Hennell.

ISBN 978-0-9947994-0-1 (bound)

 1. Burk, Kari—Family. 2. Metz, Mielle. 3. Down syndrome—
Patients—Canada—Biography. 4. Parents of developmentally disabled
children—Canada—Biography. 5. Artists—Canada—Biography.
6. Authors, Canadian (English)—20th century—Biography. I. Title.

PS8553.U6366Z53 2015 C811'.54 C2015-905178-9

All photos and illustrations by Kari Burk except where noted.
Additional text by Valerie Hennell.
Design and typesetting by Ronan Lannuzel, madebydesign.ca.

Printed and bound in Canada by Friesens.

For Mielle, Rick & Valley

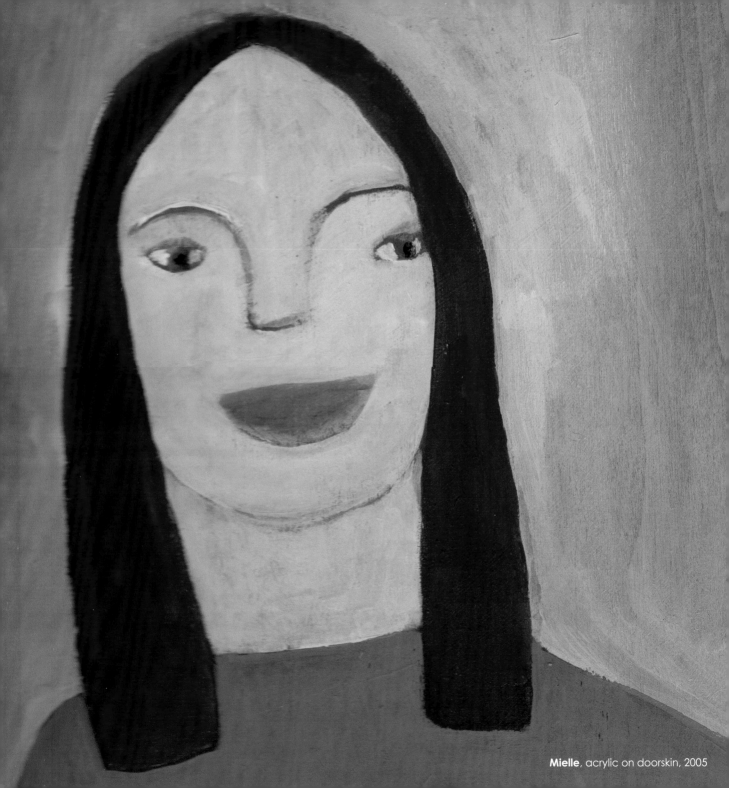

Mielle, acrylic on doorskin, 2005

This is a story of growing up with a person with Down syndrome, told in painting, drawing, poetry, photography and prose.

I'm an artist and landscape gardener living in Castlegar, BC with my 25-year-old daughter, Mielle.

This book shares our triumphs, challenges, hopes and fears, celebrating the people, places and images that have shaped our lives and inspired my art.

Perhaps the greatest obstacle faced by a person with special needs is being misunderstood and in turn, isolated, from life's processes and events.

I have enormous gratitude and appreciation for those who have opened their hearts and minds to my daughter and others with so-called disabilities.

I consider myself lucky to have been given the opportunity to have my own heart and mind opened.

Welcome to our journey thus far in the land of special needs.

Our story begins on the morning of a full moon
on International Women's Day, March 8th, 1990.

My water broke around 7 a.m. and labour was coming on fast.
As I touched the handle of the gate, I went into transition.
From the driver's seat of our '66 Volkswagen van, Jason asked me,
"Are you breathing?" and opened the sliding door so I could tumble in.
We dropped our three-year-old son Max at his grandparents' house,
then rushed to Grace Hospital.

My pregnancy had been enjoyable, inspired by an ultra-positive midwife
who focused on healthy eating, journal writing and visualization.
Max had been born by caesarean so this time I was hoping for a natural birth.
Our midwife arrived and our doctor, Bob Menzies. I liked him because he was
old school and suggested flat ginger ale when you weren't feeling well.

It was now around 9 a.m. I remember feeling quite euphoric.
I told Jason that I loved him and then pushed out this unique-looking baby.
She came out quite easily and when I saw her I said,
"Hmm, she looks rather mongoloid!" and Jason said,
"Wow, that's quite the tongue!"
and then everyone left to give us time to be with our new babe.

In retrospect I feel weird for what I said
but that's how it was in the first moments of seeing Mielle.
When Doc Menzies and the midwife came back they told us
that our daughter has Down syndrome and we thought,
"Hmmm? What is that?"

Then Grandpa Jumbulz appeared and carefully scooped her out of my arms
with a gentle but serious look that seemed to say,
"I know we can do this, Burky."

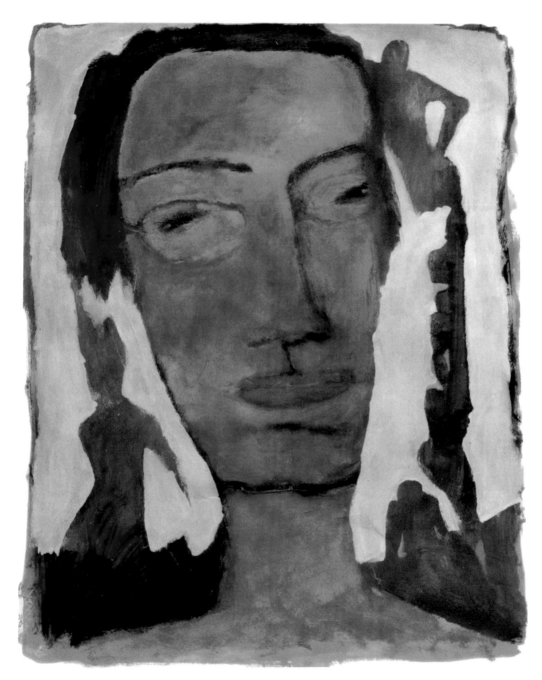

Self with Scaffolding, acrylic on handmade rag paper, 1998/2005

rays me

rays me and connect me
until I get things right.
keep me linked and loved
and don't let me ice up
like a floe without flow.
reach for me if your will.
I'm talking send in what you can, man,
if you understand
the sun and the moon
and the cosmic no plan.
close in on me
when I am far away.
see me there in the dark
a starry night spark
take my laughter
into your heart
and I will do the same
for you.

Castlegar 2012

People

Places

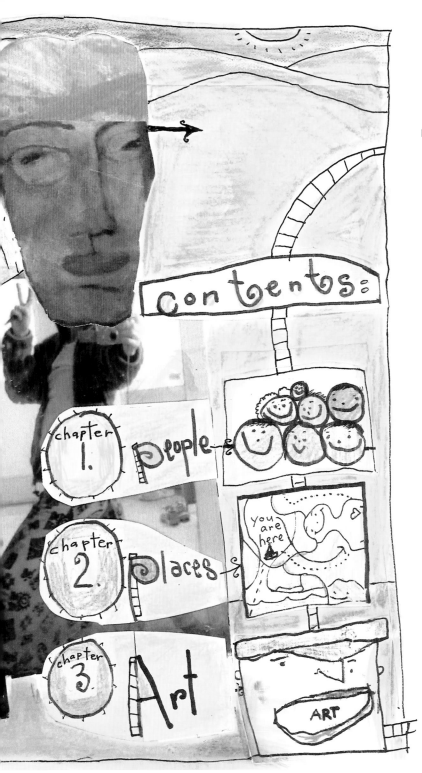

Table of Contents

Art

Woman in a Raindress, watercolour, 20

People

Mielle is drawn to individuals who bring out the best in her.
Many people in and out of our family have played
a big part in our life, well-being and happiness.

Each brings their own unique capacity and
every relationship has grown and changed over time.

We are grateful to every single person
who has chosen to be part of our journey.

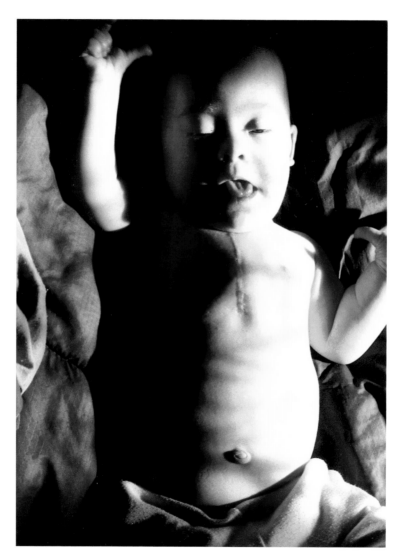

"Nice scar, kid."

Many people came to fix her heart
She was very lucky and I was very happy

Shortly after she was born we discovered Mielle had a bum ticker that would need fixing. It is quite common for people with Down syndrome to have heart problems.

One cold day at the park when she was a few months old I noticed that suddenly she was not breathing well and was turning blue.
I tucked her deep into my coat and started blowing warm air into her face but I could tell she was in trouble.

On many occasions in her first year Mielle would have these blue spells.

Max and I ran all the way home to call 911 and the ambulance came and gave her oxygen and took us to the Children's Hospital.

At eight months old she had open heart surgery to repair her atrioventricular canal.

When I first saw her post-surgery, I backed myself up against the wall and slowly slid down and almost fainted. She was in a morphine-induced coma, with a multitude of tubes and machines connected to her.

One by one the tubes were removed and we slowly got our babe back on the boob and back to her life.

When my father came to visit her he gave Mielle a fuzzy orange horse and because she is born in the year of the horse, specifically the iron horse, I saw this as a symbolic gesture that said, "C'mon little power horse, show us how strong and beautiful you are!"

Her second heart surgery at age 12 was a rough one. She almost didn't make it through. The surgeon told us she wasn't doing well and that he wanted to put an artificial valve in her heart.

I was a basket case with worry, but somehow I hung on for both her and my own dear life.

She slowly recovered and got back to her life once again. Many years later, we still have that little orange horse and we still have Mielle!

Grandpa Jumbulz said, "Our Mielle is tough as sidewalk chamomile."

Bridging the Gap, acrylic on wood, 2010

Jason
The Dad

As a young girl Mielle enjoyed her father's gentle caring nature, and as a young woman, continues to see him as a source of this tenderness. He represents a more relaxed, less intense environment than Sergeant Mom.

I would see her getting bobbled and waltzed around in Jason's arms while he watched hockey or football and I'd think a baby is lucky when this happens because they might feel they're in the thick of something important if Dad starts getting into the game!

I'm very grateful for the stable and secure environment Jason provided for us as a family when our kids were babies.

He worked full-time at a bakery as well as acting in theatre while I was a mom at home.

Both our kids were breastfed for the first two years, which was especially valuable for Mielle who needed all the help she could get to build a strong immune system.

Jason and I didn't stay together as a couple but remained together in friendship, co-parenting and educating our children. We lived near each other and lines of communication were open regarding their developing years. The kids had two homes to grow and live in, which had advantages and disadvantages, but seemed generally to flow and work.

Mielle and I moved to the Kootenays when she was 16, which created an unfortunate distance between us and our family on the coast.

A saving grace was my brother Kyle and his family living in Castlegar, who welcomed us to our new community and surrounded us with love. And Mielle, being a happy social butterfly, engaged people in her enthusiastic nature and made new friends and won hearts easily in our new town!

Mielle is very proud of her Dad, the Fire Captain of Protection Island, and likes to Skype with him on the computer and visit him and her cousins.

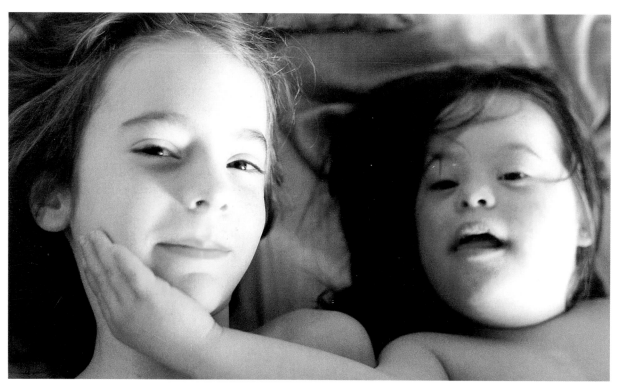

Max and Mielle, 1994

Big Brother
Max

Lurking around in me is a fear that I was overly focused on Mielle and that our son Max got the short end of the Mumzy stick. I could say that I was doing what needed to be done at the time, but I'm still working on transforming this fear.

Max was a calm and aware child and still has this nature as an adult. I often wondered how having Mielle as his sister affected him. He used to write poems when he was little and one day when he was around six he taped this poem to the wall outside his room:

Sometimes I am company
And sometimes I am alone.

When he was in his teens, Max cared for Mielle while I worked afternoon shift. He'd cook dinner, make sure she took her heart medication and tuck her in at bedtime. Having Max be with Mielle was a great comfort to me.

Looking back, on a scale of one to ten I would give myself a five or six for mothering Max. He's a lovely young man now and I love him to bits and am pretty sure he doesn't carry around bad feelings or want to say something like, "Beat it, lady, you had your chance."

Max has always been connected to Mielle and me, in a psychic if not always physical way.

I'm going to make sure there are lots of opportunities for me to bring my score up and build my relationship with him. Working on this book together is one of them.

Another poem from young Max:

Go ahead and dump compost on my head.
It's not real, it's just pretend.
Sometimes we see big fires on TV.

Max, Kari and Mielle, 1991

Photo by Jason Metz

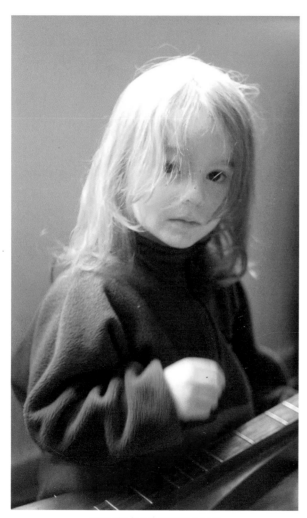

Max playing dulcimer, age 3

Dulcimer built by Bruce Sexauer

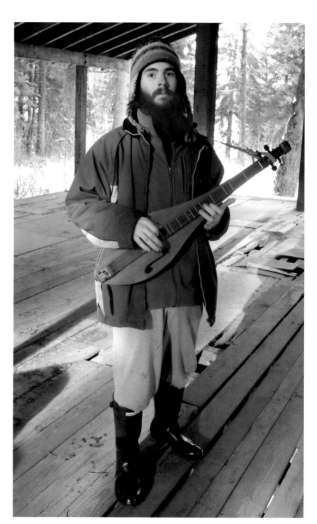

Max playing the same dulcimer on a
Kootenay mountain, age 26

Max says...

" People generally seem to assume that Mielle's influence in my childhood was mostly negative. That's not so. She's my sister, my family. I accept her as she is. Wanting her to be different hasn't been my frame of mind.

Having Mielle in my life gave me a unique perspective on personal ability and privilege, which I find truly valuable. I stay positive around her and our quality of interaction has helped me be good with other kids. I try to be supportive and help her where I can.

I never felt stigmatized. My friends didn't go out of their way to interact with her but they were generally positive.

Maybe I didn't have a huge amount of one-on-one time with my parents but I've always preferred my own company anyway. My earliest foray into independence and cooking was taking care of Mielle while Kari was working.

If I resent anything, it's when people project my being who I am as a mere reflection of growing up in a family with Down syndrome.

That sentiment doesn't allow for the ordinary reasons for my ordinary problems.

In my early 20s, I was Mielle's guardian at a week-long summer camp which gave me insight into the challenge of feeling responsible for trying to manage her behaviour.

You can't force anything on her. She is who she is and she'll do what she wants.

And isn't that inspiring! **"**

Son of Slacker, mspaint doodle, 2007

My Winter
June

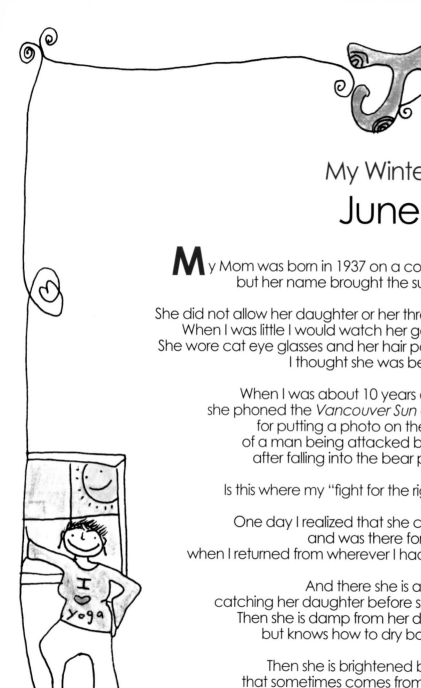

My Mom was born in 1937 on a cold January day in Alberta
but her name brought the summer to mind.

She did not allow her daughter or her three sons to give her any guff.
When I was little I would watch her get dressed up to go out.
She wore cat eye glasses and her hair poofed up and hair sprayed.
I thought she was beautiful.

When I was about 10 years old I listened as
she phoned the *Vancouver Sun* and gave them hell
for putting a photo on the front page
of a man being attacked by a polar bear
after falling into the bear pen at a zoo.

Is this where my "fight for the right" came from?

One day I realized that she cared about me
and was there for me
when I returned from wherever I had allowed myself to go.

And there she is again
catching her daughter before she hits the ground.
Then she is damp from her daughter's tears
but knows how to dry both of us off.

Then she is brightened by the light
that sometimes comes from her daughter
and her daughter's daughter.

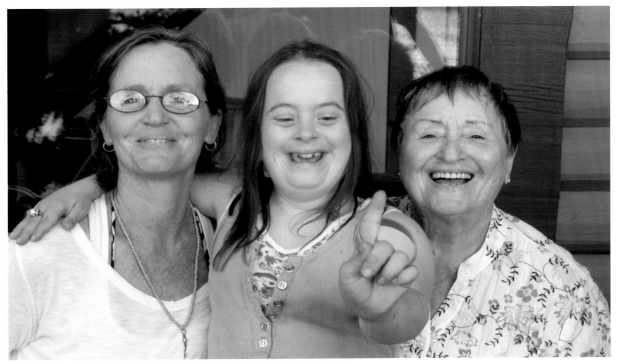

Kari, Mielle and Grandma June, 2013

Photo by Gra'ma Valley

Grandma June says...

" *There have been lots of ups and downs in our life together, especially when Mielle has been sick, but we are hanging in there.*

When she was 12 and had her second heart surgery, I was sitting in the waiting room and I yelled at my God, 'I'm not finished with this girl yet, so please get her through this surgery!' And He answered my prayer.

So every day I thank God for her presence in my life. When I see people with Down syndrome I smile at them to say, 'Hey, I know somebody like you and I am very proud of her and you!'

She's been a joy to me and our family and we thank everyone who has been there for Kari and Mielle as they travel this road together. "

Gold Cloak, acrylic on canvas, 2015

Grandma
P'Chi

P'Chi is Mielle's grandmother. Her love of singing connects her to Mielle who also loves to sing.

Together they travel a joyful sound journey which P'Chi describes as a way they can be together "without the baloney in between."

In the late 1980s our family went to hear P'Chi sing with The Universal Gospel Choir in Vancouver quite a few times. It was always an emotionally moving and beautiful event for me.

P'Chi sees singing as a "fundamental gift" we all have that can develop through practice the same way an athlete trains for a sport.

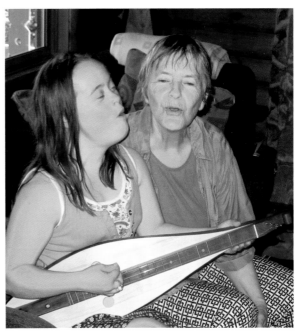

Mielle and P'Chi, 2013

Grandma P'Chi says...

❝ *People with Down syndrome thrive in an environment of love.* ❞

Gra'ma
Valley

Working with Valerie Hennell is akin to witnessing the tenacious and determined dung beetle who somehow, some way, moves the "ball of importance" with its back legs for miles into its purposeful place. In ancient Egypt, the dung beetle was revered as the sacred Scarab.

Valley's ability to organize and fan artistic flames is well-known, respected and appreciated by both art-makers and audiences. In the world of women she is in the "Shining Example" category for her capabilities as a creative writer, businesswoman and producer.

On many occasion I have said to myself, "How the heck did I get so lucky to work with someone who excels in all the stuff I suck at?"

Valley is Mielle's grandmother by marriage and by choice. Her interest in my life as an artist and as the mother of a person with Down syndrome is the foundation for this book.

When we feel support and encouragement from someone who recognizes what can be grown in the fertile ground of our person, we can begin to get down to the soulful work that is beneficial to both self and others.

Valley's confident awareness that we would travel both the deep dark and bright light places kept this project on wheels and rolling.

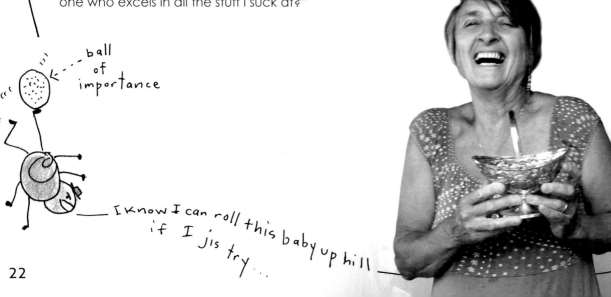

ball of importance

I know I can roll this baby up hill if I jis try...

22

Gra'ma Valley says...

" *My connection with Mielle did not come quickly or easily. At first I was startled by her honesty and unfettered laughter. It took years for me to find a comfortable place with this guileless being who welcomes me despite my awkwardness.*

Then one day she invited me into her room— her sanctuary—and we began communicating in a way that wasn't about words as much as intuition and trust. That's when I started to understand that my clanking self-protective defensiveness is a kind of disability.

Mielle always has new insights to teach me. One day walking along the beach she looked up at me and howled 'Valley, RELAX!'

Words to live by, Mielle! **"**

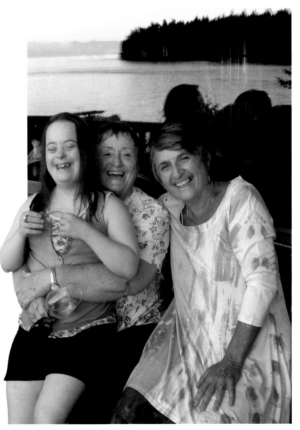

Mielle with Grandmas June and Valley
Protection Island, 2013

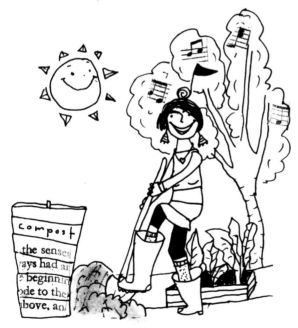

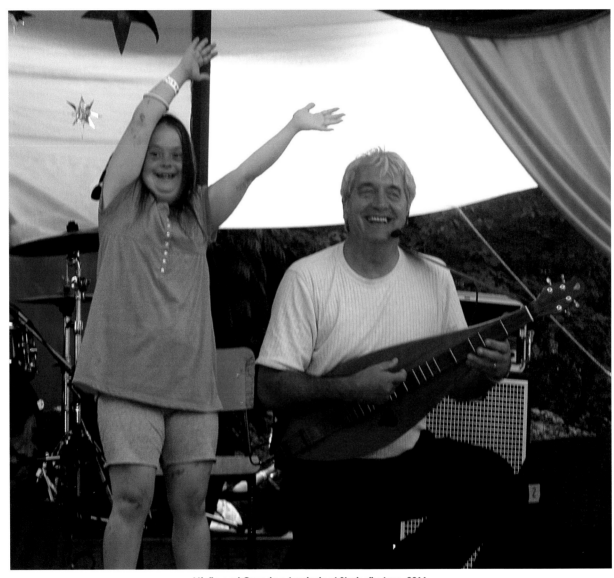

Mielle and Grandpa Jumbulz at Starbelly Jam, 2011

Photo by Gra'ma Valley

Grandpa
Jumbulz
Rick Scott

Mielle first met her grandfather in hospital a few minutes after she was born. Something must have been forged between these two souls for they would go on to do much great work together. Rick's nine grandkids call him Jumbulz, and Mielle also delights in calling him "Big Boy."

Rick Scott is an internationally acclaimed folk musician, family entertainer and one third of iconic BC trio Pied Pumkin. Because of Mielle, he is also Goodwill Ambassador for the Down Syndrome Research Foundation.

Being part of the life of a person with Down syndrome is not everyone's cup of tea but Rick was willing to give it a try, adding a warm-hearted magical-musical spin accompanied by his trusty Appalachian dulcimer.

When Mielle was five years old, Rick wrote "Angels Do" - a song that has touched hearts worldwide and become a kind of anthem for people with special needs.

Rick and Valley crafted a video of the song starring Mielle which ran for 10 years on Treehouse TV and is now on YouTube.

People often approach me to say what a beautiful piece of work it is and how their children see themselves in Mielle! You can see it at www.rickscott.ca/videos.

For Mielle and her Grandpa, the song has evolved into a kind of secret language that they speak, sing and yell together at every opportunity, with glee and hilarity. She never misses a chance to climb on stage with him to dance and sing along.

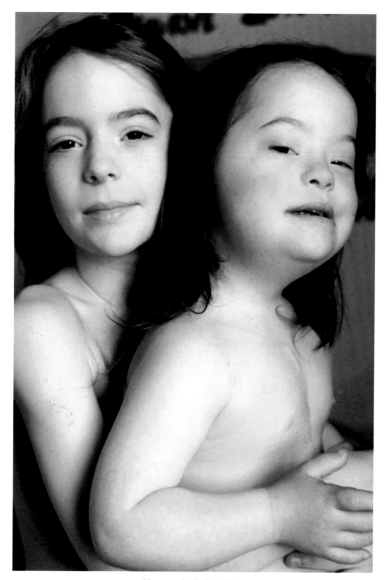

Max and Mielle, 1994

Grandpa Jumbulz says...

❝ *When Max was born our family rushed to the hospital with toys and flowers to celebrate this new addition to our clan. So when the second grandchild was imminent, we were ready to party. But as we came down the hall a nurse stopped me and said, 'Mr. Scott, before you go in the room we need to talk to you. Your granddaughter was born with Down syndrome.'*

Everything collapsed. I felt panic, anger and fear. I started yelling that they'd made a mistake. They were trying to tell me about an extra chromosome. In those moments I had thoughts so terrible that I still feel ashamed to this day.

The proud patriarch, the guy everyone looked to for comfort and laughter, just stood there feeling helpless and humiliated. Then the nurse said, 'Mr. Scott, go meet your granddaughter.'

As soon as I walked into the room, I realized all those fearful feelings were somehow important so I could walk through that door into a new reality.

I realized that for better and worse, our family had been given an angel. But this is not the Hallmark card kind of angel. Instead of wings this angel would have scars. She couldn't fly but would walk on this earth and people would not want to look at you, or worse, would stare. Often you would be shunned.

This angel would teach me new ways to laugh and cry and show me a world I never knew existed. At the end of a day you'd be exhausted, but perhaps your heart would be a little bigger and you'd have discovered a new understanding of the word 'compassion.'

Holding my new granddaughter in my arms my first reaction was, what can I do, I'm only a musician? At that moment my music seemed painfully irrelevant.

Then I met Josephine Mills who was working on a great big vision out of a tiny dilapidated trailer on a vacant corner of Sunny Hill Health Centre for Children in Vancouver. She was creating the Down Syndrome Research Foundation to gather information and develop programs for and about Down syndrome.

Goodwill Ambassador

"Jo Mills asked me to play a concert for a hundred children with Down syndrome and their families in the Ballroom of the Hotel Vancouver. I stayed up all night trying to figure out what to play.

The only person with Down syndrome I'd known was Snowflake, during the heyday of the Pied Pumkin. Every time we played in Courtenay, a child would sit on the edge of the stage and beam at me until I beamed back. Over the years we became great friends, greeting each other with a hug and a laugh.

Decades later, trying to make up a song for kids with this special need, I invoked my memory of Snowflake and the spirit of my tiny grand-daughter. And the thought I kept having was, 'Angels, angels, what is it about these angels?'

I scribbled down everything I knew about angels on the back of an envelope and lyrics began to appear. By morning that envelope was smeared with chocolate and coffee. 'You look like these angels do' gave me the title and chorus. The first sound I heard Mielle make was 'Hah' and now it seemed like the angels were laughing at my dilemma. 'Hah Hah yeah!' became part of the refrain.

The next day's performance was a swirling noisy circus of enthusiasm that taught me many important things about my new audience. They mimic, they vocalize, they air guitar, they rock! Sorry, folks, it's a typo! It's not DOWN syndrome, it's UP syndrome!

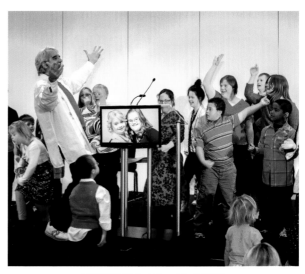

DSRF Christmas Breakfast, 2012

Photo compliments Callaghan Photography

We recorded 'Angels Do' for my Philharmonic Fool *CD and it took on a life of its own. Every player added magic until somehow it sounded like angels singing.*

We coaxed five-year-old Mielle into an angel costume to film a video with a borrowed back-drop and homemade props. Valley followed us around with a Hi-8 camera, shooting footage of Mielle in her day-to-day of life.

Treehouse TV showed 'Angels Do' 20 times a month for 10 years and it became one of their most requested videos.

Jo Mills passed away but her legacy lives on. The Down Syndrome Research Foundation is now housed in a magnificent light-filled facility in Burnaby, BC, offering world-class programs to children and families. I'm honoured to be their Goodwill Ambassador. "

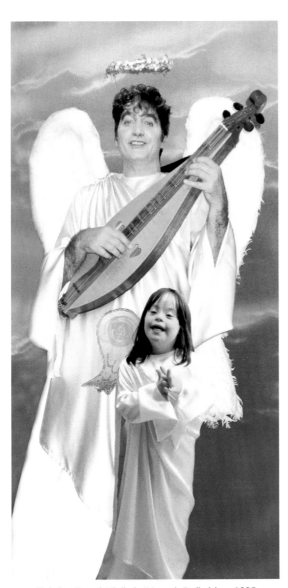

Rick Scott and Mielle in "Angels Do" video, 1995

Dulcimer built by J.R. Stone. Photo by Gra'ma Valley.

Angels Do

I always thought they had a big old set of wings
with flowing robes that would never ever cling
and played on harps that had at least a dozen strings
and gathered up in groups to sing and sing and sing
but you look like these angels do
and angels look just like you

I always thought that they could fly without a care
and stand around on clouds that floated in the air
and if they lost a part they always had a spare
for which you must admit is really rather rare
but you look like these angels do
and angels look just like you

I always thought they had a halo on their head
which is so right at night for reading in your bed
I don't believe it but you know I've heard it said
to be an angel that first you must be dead — no!
you look like these angels do
and angels look just like you

Well they can join a choir or they can join a band
and they originate in many different lands
and do not worry 'cause they always understand
that when the music's hot they can clap their hands
and you look like the angels do
and angels look just like you

Hah hah yeah!

Written by Rick Scott, from the CD Philharmonic Fool

Copyright © Grand PooBah Music 1995

www.rickscott.ca/videos

29

Upside of Down

Around the world many local, national and international organizations are dedicated to improving the lives and understanding of people with Down syndrome.

The first week of November is Down Syndrome Awareness Week, sponsored by the Canadian Down Syndrome Society and Down Syndrome Research Foundation and many local associations.

March 21st is World Down Syndrome Day, a global awareness day officially observed by the United Nations since 2012. The date was chosen to recognize the trisomy of the 21st chromosome, and is celebrated by wearing lots of brightly-coloured mismatched socks.

Every three years in August, the UK-based international charity Down Syndrome International presents a World Down Syndrome Congress in different locations around the globe: in Chennai, India in 2015 and in Glasgow, Scotland, in 2018.

In 2006 the World Congress was held in Vancouver, BC, with Rick Scott and Fred Penner as musical hosts. They started each day by singing "Upside of Down," a theme song written with Valley Hennell and later recorded with Joe Mock and Shari Ulrich for Pied Pumkin's CD, *Pumkids*. I was invited to illustrate the lyric booklet.

In 2007 *Pumkids* won Parents' Choice Approved, NAPPA Honors and Canadian Folk Music Awards.

A video of "Upside of Down" featuring many alterabled artists who performed at the 2006 World Congress can be seen at www.rickscott.ca/videos.

Illustrations, *Pumkids* CD, watercolour, 2006

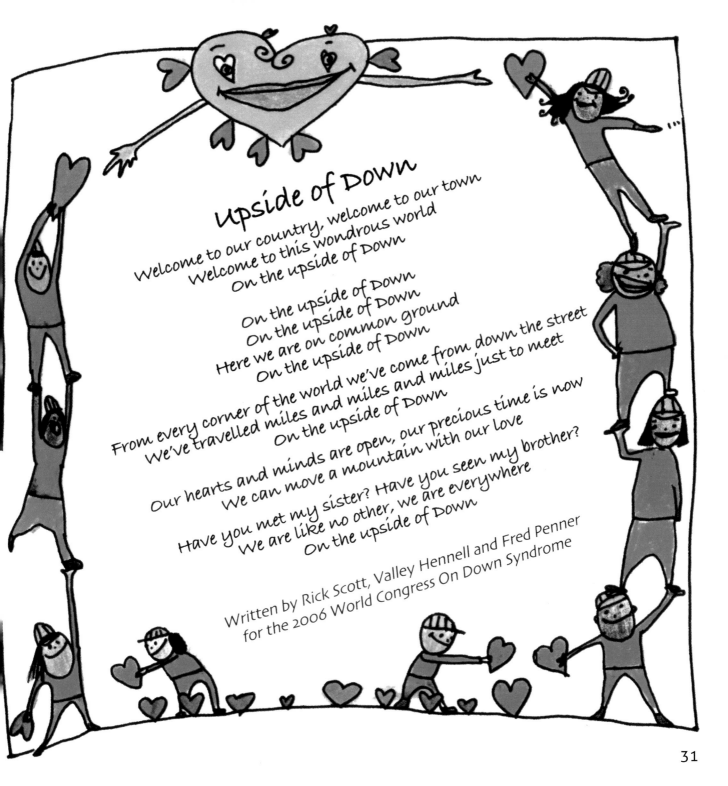

Upside of Down

Welcome to our country, welcome to our town
Welcome to this wondrous world
On the upside of Down

On the upside of Down
On the upside of Down
Here we are on common ground
On the upside of Down

From every corner of the world we've come from down the street
We've travelled miles and miles and miles just to meet
On the upside of Down

Our hearts and minds are open, our precious time is now
We can move a mountain with our love

Have you met my sister? Have you seen my brother?
We are like no other, we are everywhere
On the upside of Down

Written by Rick Scott, Valley Hennell and Fred Penner
for the 2006 World Congress On Down Syndrome

Noella Tremblay
Special Education Assistant

When Mielle started school she was appointed a Special Education Assistant to help her each day. An inspirational, enthusiastic, warm-hearted woman with a great sense of humour, Noella included Mielle in anything and everything. If a modification was needed, Noella was willing to give it a try. She took many photos of Mielle in action at school which are still the source of many fond memories. This early introduction to photography as a visual learning tool inspired me to draw and use photos at home for 'sequence mapping'—to show the order or manner of doing tasks like getting ready for bed or going to school (see page 73). Almost two decades later we are still in touch. We love you, Noella!

Noella says...

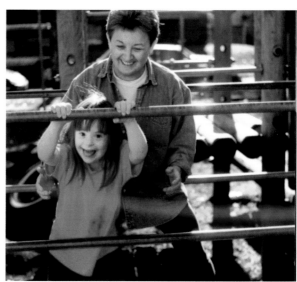

Mielle and Noella, Lord Tennyson, 1998

" *My work has been inspired by Rudolf Steiner's Anthroposophical teachings, the philosophy of Jean Vanier who founded the L'Arche Community in France, and the teachings of Jesus to love 'the little one' in His name.*

I started working at age 19 in Quebec with a class of girls labelled debilles ('mentally defective'), a term I didn't like as I felt I had challenges of my own. I saw them as my little sisters and did what I could to ensure we had good days, self-esteem and practical things to help us in life.

This work is from the heart and gives me opportunity to become a better person. The great people in need of special care allow me to be their friend and assistant, they trust me with all their heart. My first thought is that if I were this child or student, how would I like to be treated? How would I like my own child to be treated?

To be loved and accepted the way he or she is, with the dignity to be seen as intelligent or brilliant, with talents, never mind how they are expressed. Then creativity allows the child to BE and be respected and seen as a part of the class and the world. **"**

Inspirational gold nuggets from Noella:

"Opening doors without opening the door."
"Never give up, always trying."

Nova MacDougall
Residential Community Worker

Since she was 19, Mielle has participated in the Adult Day Program of Kootenay Society for Community Living (KSCL), which she now attends five days a week in Castlegar. She's had a variety of one-to-one community support workers and Nova MacDougall, Team Leader of the Day Program, is one of her favourites.

Nova says...

" I have always worked in caregiving professions. I answered an ad for KSCL 25 years ago and at the end of the first day they asked if I wanted a full-time position and I said 'yes!'

I like how easy it is to make people happy and how the simplest things bring joy. I try to practice 'be here now' as a personal philosophy. People with special needs do live in the moment more than most of us.

You don't have to do much, just be kind and helpful and it means so much to them.

These people are my family. I've known some of them for years, I've seen their life experiences. They are my friends and knowing that I know them is a comfort to them.

They are all individuals so I look at each person, where they are in their life and which goals would be most beneficial.

We focus on social skills, life skills and helping them be as healthy as possible, both physically and emotionally.

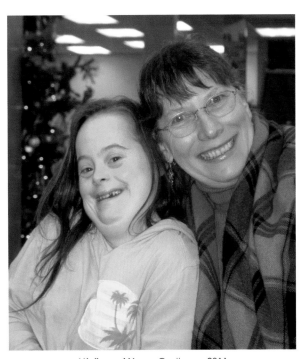

Mielle and Nova, Castlegar, 2011

I try to make having fun my number one goal. They allow me to be myself, so the clown comes out and it's just fun! "

Paul Simpson
Sir Noble Goldenheart

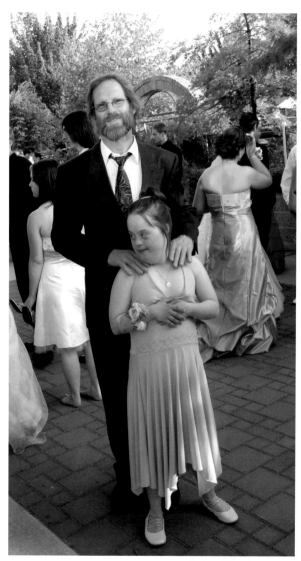

Paul and Mielle at Graduation
Stanley Humphries Senior Secondary, 2008

When Mielle was graduating from high school in 2008, her Dad was unable to attend her Grad, so my boyfriend Paul offered to be her "date" for the Grand March. They were quite the couple that night! Mielle calls Paul "Big Sir."

Later we three moved to Pass Creek, a rural settlement north of Castlegar established by Doukhobors in the 1920s.

Paul and I share a mutual love and respect for plants and trees. We had a huge garden, a tree farm, five dogs, several chickens and a separate art studio where I did a lot painting.

Paul and Mielle shared much laughter and positive time and their relationship sometimes seemed more successful than ours!

Pass Creek carries melted snow water down from the Selkirk and Ladybird mountain ranges and is full of forest, horses, elk and bear. In the spring we'd watch the beavers, incredible engineers and architects, reconstruct their dams to accommodate the water's flow. In summer they allowed us to swim in their swimming holes while they floated nearby, calmly watching us.

The rural setting was great for me but not for a young woman becoming her independent self, developing wings to one day fly from Mom's nest. Missing was the social connection to people and events that city life provides, so after four years in Pass Creek, Mielle and I moved back to Castlegar.

Opposite page: **Grandma June / Mrs. Read / Peer tutors Susie and Lisa / Cousins Solly and Malcom**

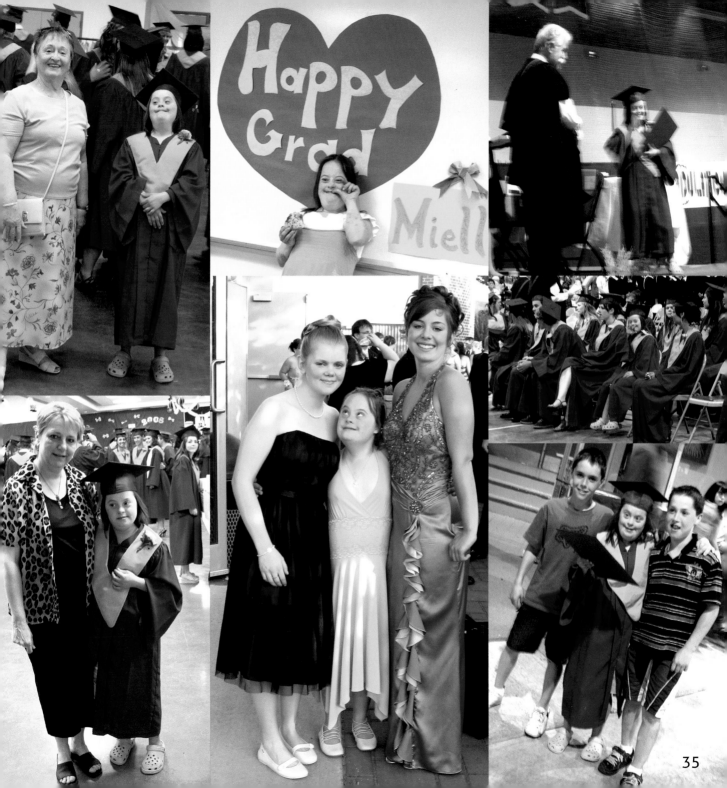

Paul says...

" Mielle is the first person with Down syndrome I've spent enough time with to 'learn her lingo.' For example, 'pasta-roll'— a blending of Italian and French that only she could make sound so delicious.

Having once eaten a wonderful pasta casserole, she surprised me while I was whipping up a quick batch of Kraft dinner by announcing with great enthusiasm, 'Yeah... pasta-roll!' Now there's a girl that's easy to please!

Mielle says she's my 'sister girl' so I guess that makes me her 'brother boy' which I think means not as close as a boyfriend and not quite a brother.

Growing up, I'd meet people with special needs on the bus or at the park but didn't have the courage to talk to them. Until I met Mielle, I'd feel anxious and not know what to say. But once I had one thing to talk to her about, it grew from there, just like any relationship.

When as a teenager I didn't know how to talk to my sister who was deaf, my Mom said, 'Well, you didn't try!' The great rewards in this life come with extra effort.

Paul and Mielle in Larry the Truck, 2011

I met Mielle when she was 17, an outgoing teenager ready to engage with this new person Mom invited over. We lived together for four years and escorting her to her high school graduation was a very proud moment for me.

The look on her face, standing on the podium with hundreds of people cheering for her! The photo in the newspaper the next day showed her beaming with joy.

Mielle has a boyfriend now, so the automatic lead in is, 'How's your boyfriend doing?'

The love of her life, Dustin is one of her friends from KSCL and he told Kari that he liked her daughter soon after they met five years ago. Now they are an item and Mielle says she'll move in with him in six years.

Numbers are arbitrary with Mielle and she has a certain preference for six.

Mielle loves to greet people! Why does everyone have a smile on their face when they take time to stop and say hello to her?

Because it's a blessing to be able to share with her and try to understand how she sees things. It surely taps a part of you not stimulated with any other kind of human relationship —a lesson in humility perhaps.

A 'Soul Place' is much deeper than our earthly perception. It connects with a universal energy that touches us in ways we might find hard to understand.

Perhaps those with extra challenges have this gift so they may experience relating with younger, less experienced souls while in this realm.

So we don't know why we are blessed when we relate with Mielle, we just understand that this 'Soul Place' is a special place very close to our heart. **"**

Mielle with Dustin Roberston, 2014
Photo by Kathleen Elias, Executive Director, KSCL

Ragzy
Friend and Artner

My good pal Rick Michalski and I have known each other for decades. We shared an art studio in Vancouver and did all kinds of crazy creative things together and with other artists: an exhibition of kids' art, video docs, poetry readings, bookmaking, drawing and painting. We call ourselves "Artners in Grime."

Ragzy is an inspirational friend and artist. He's been with me on the high peaks of joy and in the dark valley shadowed by a looming mountain of sadness. He has listened to my woes and wonders and joined in on many a family celebration.

If you have a good friend like this, cherish them because they give you confidence and help you to be who you are.

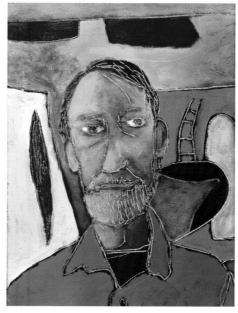

Ragzy, acrylic on canvas, 2005

Here's a poem that Ragzy sent to me in 2012:

I knew by how you placed
the rocks in your garden
I knew by what kind of food
you fed your children
I knew by how you lived
with the earth and air
I knew by your firewater garden blood
our friendship was sealed
centuries ago.

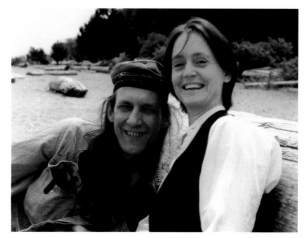

Kari and Ragzy, Jericho Beach, 1992
Photo by Max Metz

Kari
Mumzy The Gardener

Kari the Gardener,
ink on paper with MS paint, 2009

"All my hurts my garden spade can heal."
Ralph Waldo Emerson

Sometimes I ask myself, "How the heck did you become a gardener, Kari?"

It's a profession that I didn't plan or see coming. I always enjoyed my Granny's garden and having plants in my room when I was a kid, but I was usually dreaming about becoming a writer, painter, dancer or filmmaker.

But I love this work and from March to November I operate Muddy Tutu, Organized Grime and Garden Art, a landscaping and gardening business for people in my community.

I enjoy helping people with their garden plans and working with the cycles of nature. And while I'm busy with my work, Mielle is busy with her life with her KSCL group, so our time apart is well spent and we come back to our lives together refreshed.

This is me sitting in the sod wall compost I built, designed by a woman I garden for, Shemma Goodenough.

You have to layer up bricks of sod into a wall, grass-side down, so the grass dies, then cover with a sheet of dark plastic. The middle can be filled with composting material. If you want to turn a section of lawn into garden, this is a great way to repurpose sod.

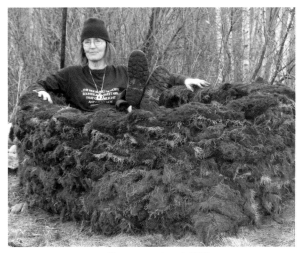

Kari in compost nest, 2012

Photo by Shemma Goodenough

Valley and I love compost. We often marvel at how it turns the discarded into gold. It can be dirty and stinky but so well worth it. Just like life!

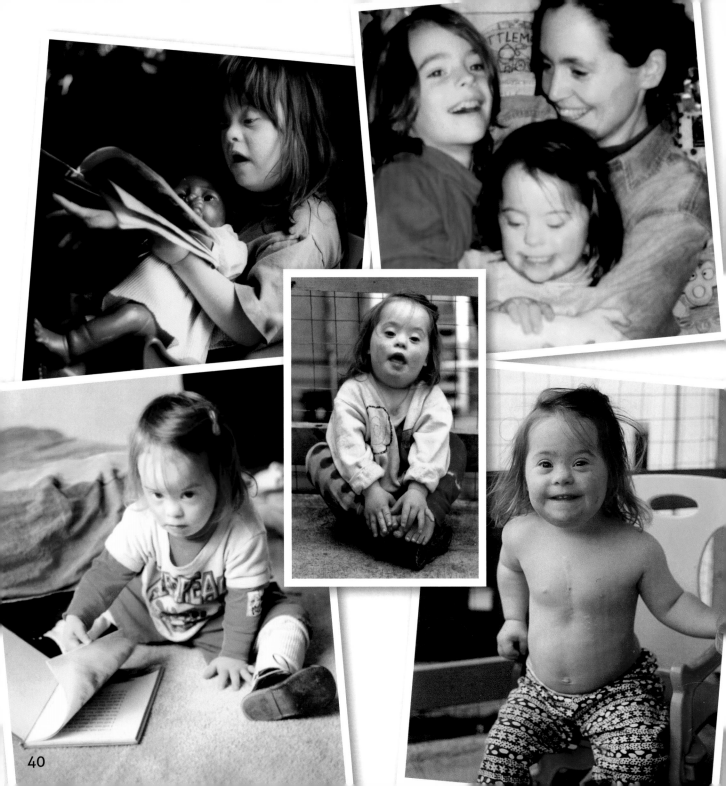

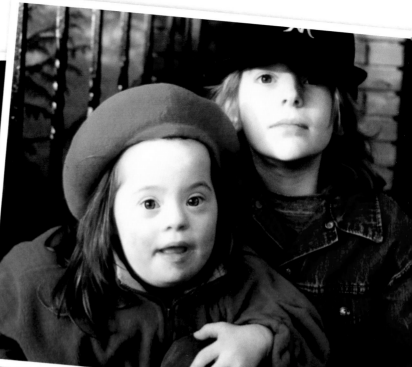

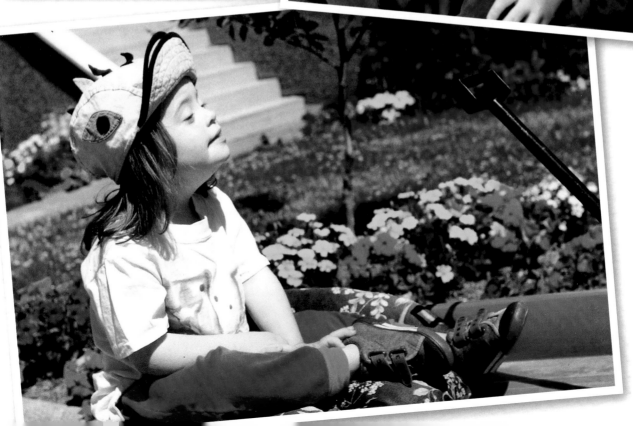

Kari at Waterloo Eddy in Pass Creek Regional Park, Spring 2012
Photo by Mielle Metz

Places

where we meet
where we are alone
where our choices become us
where we practice in quietude
where I'm unexpectedly inspired
not looking but finding
where I call upon the earth
and my call is returned

Some places we choose to go and some places choose us.

These are some of the significant places in Mielle's life.

Vancouver Children's Hospital

The cardiology team and nurses who helped Mielle are permanently etched in my mind, specifically surgeon Dr. LeBlanc and cardiologists Dr. Patterson and Dr. Hoskins. I'm sure I was a pest to many of the medical staff with all my questions, concerns, insecurities and emotions but they always made time to help me. The nurses in intensive care post-surgery were solid and amazing people; you have to be to see a tiny babe through these medical procedures. We became well-rehearsed in the art of hanging out at a hospital as we returned again and again for a variety of reasons ranging from post-surgery fluid in Mielle's lungs, to an infection in her incision site (a bit of surgical suture was found), to dental procedures. I feel perpetual gratitude for the Vancouver Children's Hospital.

Vancouver Breastfeeding Clinic

A baby with Down syndrome might have difficulty breastfeeding due to hypotonia (low muscle tone) and need to develop muscles around the mouth and endurance, much as a woodwind player has to develop their facial muscles or embouchure (from the French word *bouche* meaning mouth). So we went to the Breastfeeding Clinic to be coached in the art of suckle.

Max climbed aboard the boob gravy train for two years right after birth. But Mielle's heart condition made her tire easily and she had trouble latching on, so there was a possibility of not getting enough milk.

The Clinic weighs the baby before and after feeding to see how much milk is getting in. The women sit and guide you as you breastfeed: a beautiful service promoting good health right from the start.

Mielle became an awesome breastfeeder and after heart surgery her endurance was much better. We finally had to wean her cold turkey when she was two and a half!

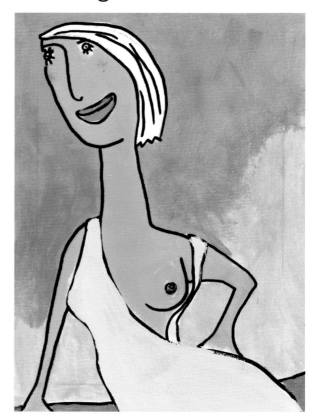

Olga The Magnificent, Acrylic and Sharpie ink, 2015

Vancouver Infant Development Program

We connected to another excellent service where a specially trained physiotherapist came to our house to teach us and Mielle how the "moving parts" of a baby with Down syndrome work. Because of low muscle tone, developmental stages such as holding the head up, sitting up, crawling and walking may take much longer. The therapist brought all kinds of toys, chairs, books and games modified for special needs babes for Mielle to "work out" with. Our therapist Edwinna was such a lovely and caring person. Wherever you are, thank you so much for your gentle, kind nature and good work!

Sign Language Class

We were advised to take a sign language class when Mielle was a baby because people with Down syndrome tend to be visual learners. I loved learning sign language and how beneficial it was for communication.

For Mielle it opened the world of getting her needs understood and met and connecting to things and people. She still uses a lot of sign language, albeit a slightly "Mielle-i-fied" version!

Lord Tennyson Elementary School

Mielle began school in the "Open Classroom" at Lord Tennyson, a beautiful old red brick schoolhouse in Kitsilano, the neighbourhood where we lived in Vancouver. The top floor was a huge bright open space with walls removed so that kindergarten and Grades one, two and three worked and played together.

The teachers created a great setting where older kids were helping the younger ones and the entire group would come together for all kinds of activities. The school placed a lot of attention on individual interests and achievements.

Mielle placed a great deal of importance on her lunch. One day her S.E.A. Noella told me she would be receiving an award at the next day's assembly. What was the award in recognition of? Behaving so well at lunch time! Thank you, Lord Tennyson!

Student teachers Tina & Elisha

Music with teachers Marion Stroet and Laurie Linton, 1998

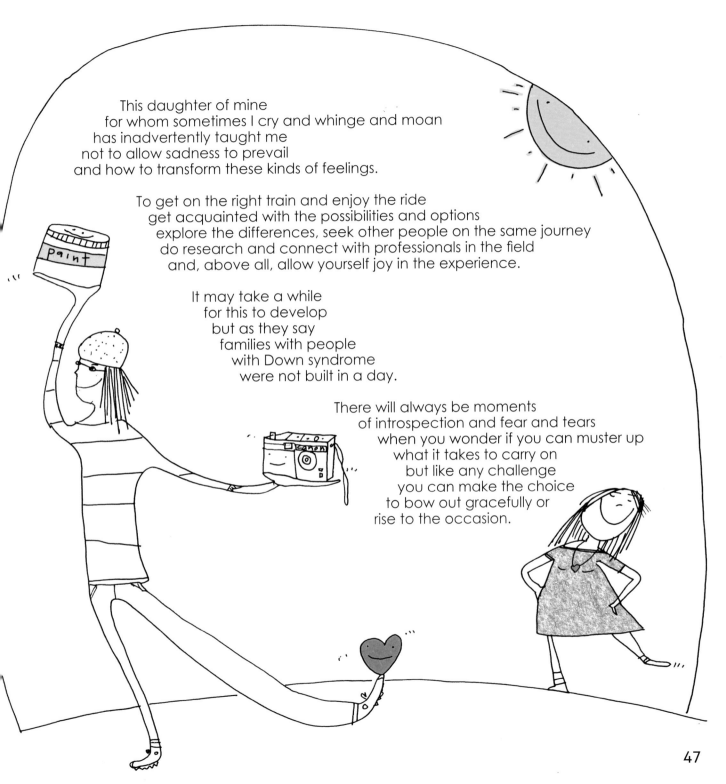

This daughter of mine
for whom sometimes I cry and whinge and moan
has inadvertently taught me
not to allow sadness to prevail
and how to transform these kinds of feelings.

To get on the right train and enjoy the ride
get acquainted with the possibilities and options
explore the differences, seek other people on the same journey
do research and connect with professionals in the field
and, above all, allow yourself joy in the experience.

It may take a while
for this to develop
but as they say
families with people
with Down syndrome
were not built in a day.

There will always be moments
of introspection and fear and tears
when you wonder if you can muster up
what it takes to carry on
but like any challenge
you can make the choice
to bow out gracefully or
rise to the occasion.

"Are you a monster?"
he asked while climbing around
at the playground.
"No!" she said with
a laugh.

Is that cat green?

Why is it green?

I'm not used to seeing a green cat.

Why does it have two different eyes?

Eeeek! I'm afraid of it!

Is it a monster?

Where does it come from?

What happened to it?

I don't know If I can be friends with it.

Yikes! That cat seems weird to me!

Green Cat, watercolour, 2012

Inclusion

I created this *Green Cat* painting in response to Mielle being innocently asked by another child, "Are you a monster?"

The love, care and acceptance shared within families and friendships sometimes has to carry the weight of its opposite, which is exclusion.

I remember how painful it was when Mielle was younger and some kindly person would have to tell me that she couldn't participate in a class or program because she required one-to-one attention.

I would climb into the car and weep, and Mielle, oblivious to the problem, would ask me, "Why mom?"

In her teens Mielle started talking about "kids' eyes" when we were in a grocery store or park. I realized she was aware of children staring at her because she is different and on occasion this would bring her to tears.

We'd suggest not letting it bother her, that kids stare because they're curious and maybe she could say hello and make a friend.

But her feelings were getting hurt because she didn't feel accepted. She thrives on social interaction and is highly sensitive to failure.

I first saw a person with Down syndrome at eight years old in the corner store and I did the exact same thing: I stared for a very long time.

The storekeeper was kind enough to notice my bewilderment and talk to me about this special person which helped me not be afraid.

Children who are exposed to the world of special needs are more comfortable with differences. Inclusion in whatever way possible is extremely valuable for all concerned.

I try to stay positive for myself and Mielle but there have been many times where I too have cried when a wall suddenly appears.

I have to look to my skills and practices to create a door or window in this wall, to see it as an opportunity more than a struggle, to move forward with good choices and keep rowing the love boat gently down the stream.

begin where?

I'll begin by digging at the base of the wee cedar
that my brother planted a few years ago.
I'll remove the grass and other unwanted plants
that are growing around the cedar's roots.
I'll put back the cleaned soil around the tree's base
and place a circle of stones around it.
I'll take the tear on my cheek
that is composed of ancient waters
and place it on the soil.

Then I'll go back to work as if this had never happened.

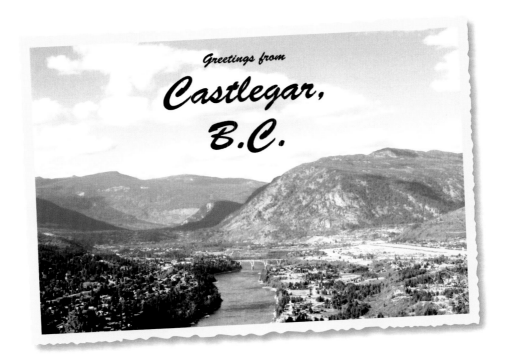

Greetings from
Castlegar, B.C.

Good Morning, Castlegar!

In May 2006, Mielle and I moved from our sea-side home in Kitsilano to the land of awesome mountains, valleys and rivers in the Kootenays.

This was a dream that had percolated for 10 years since I went to my brother's wedding in Rossland and fell in love with the area and said to myself, "I'm moving here one day."

So when the City of Vancouver decided to tear down our house to build social housing, the time was right to make a move.

Max was 19 and ready to lead his own life and he wanted to stay in Vancouver. I knew I'd miss him and my Mom, but my brother Kyle and his wife and three sons are in Castlegar and I wanted to live near family.

Friends wondered why I wasn't moving to Nelson which is more of an arts community, but I felt confident that art is within me and I can take it wherever I go. As it turns out, Castlegar has a great cultural community which just keeps getting better.

Our new town has a multitude of artists and hosts annual art and sculpture walks. It was recently named "Sculpture Capital of Canada."

The Kootenay Gallery supports local and international art and music and we're proud of the beautifully refurbished Old Castle Theatre and its involvement in our community.

Moving away from Vancouver marked a big turning point for me and Mielle. We were living together alone for the first time.

She was moving from childhood to adolescence while geographically separating from her beloved Dad. Major change was required to meet the challenges of our new life.

I was happy to see her enjoying our new town. We'd go for walks in the morning to explore and when we walked out the door, she'd say, "Good morning, Castlegar!"

That warmed my heart and let me know both of us were up for this new adventure.

The Community Centre was just a short walk from our house so we enjoyed the swimming pool, ice rink, outdoor play area and skate park. That summer Mielle led the Take Back the Night rally with her homemade heart-shaped sign.

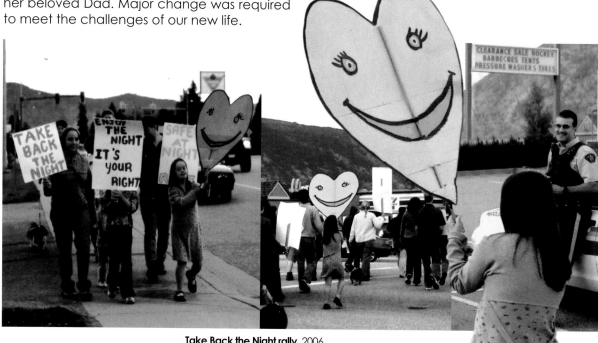

Take Back the Night rally, 2006

I see
that you are
a lovely young woman now.

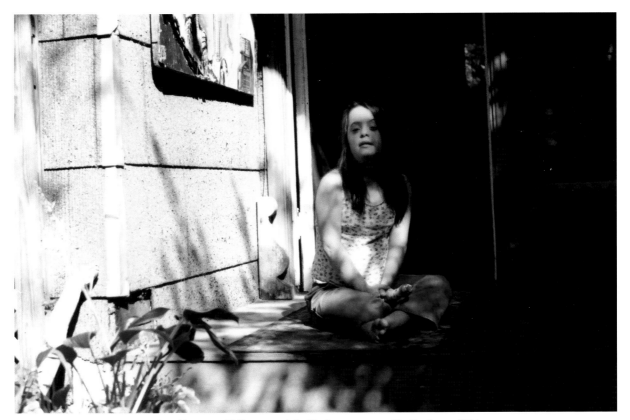

Age 16, on our Kistilano porch just before we moved to Castlegar, 2006

A New High School and Super Cool Cousins

When we had been in Castlegar for a month my brother Kyle asked, "How are people reacting to Mielle here?"

I remember feeling good letting him know that people had been kind to her and our experience so far was positive.

Mielle loved visiting Uncle Kyle, Aunty Tammy and their three boys. I was so grateful for how they opened their hearts to us.

Mielle's social worker at Community Living BC in Vancouver contacted the Castlegar branch to let them know that Mielle was moving there.

So we were right away connected to Kootenay Society for Community Living, just a few minutes from our house.

Mielle entered a summer program of activities and adventures for teens with special needs and we became good friends with a support worker named Lauren and her son, Jaia.

While Mielle was at the program during the day I had time to do garden work for people and get to know my community.

She was 14 and going into Grade 10 at the local high school. We met with the Special Education staff in the summer to make plans and create a program for her.

Mielle and her dear pal with a heart of gold, Community Support Worker Lauren Carter, who now works as a nurse in Nelson, BC

On her 18th birthday, tucked into the love of Uncle Kyle and cousins Malcolm, Nigel and Solomon

Acting Class

The Special Education instructors at Stanley Humphries Secondary were excellent. Mielle's reading skills developed by leaps and bounds with the help of the appropriately named Mrs. Read, who went over and above to help us both in and out of school.

Mrs. Poznikoff took Mielle to drama class where she was invited to perform her favourite songs on stage with other teens. It was beautiful to see her so graciously accepted and heartwarming to see her in performance, knowing she had done the hard "work" of rehearsals to get there.

Thank you to the drama teacher, Mrs. Voykin, for giving her this opportunity!

When Mielle graduated in 2008, we decided that she would return to high school for one more year while she was gradually introduced and could make the transition to the adult program at KSCL.

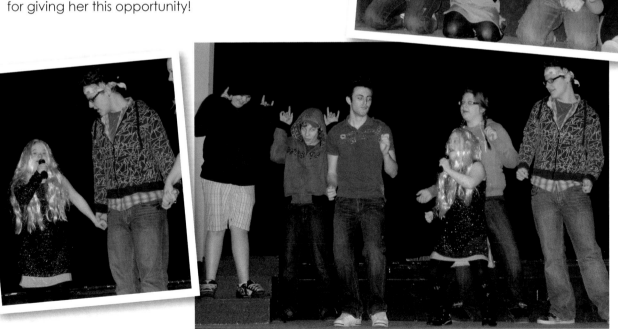

High school drama class, 2008

KSCL pals getting ready for the Sunfest Parade, 2010

Mielle and Heather at the
Christmas dance, 2011

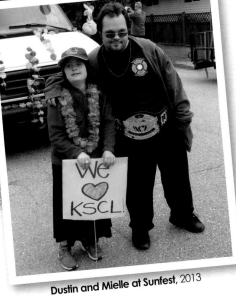

Dustin and Mielle at Sunfest, 2013

Kootenay Society for Community Living

Mielle and I love Kootenay Society for Community Living! They have contributed in a huge way to the happiness and stability of our lives. The Adult Day Program provides her with an opportunity to be with friends, peers and support staff who assist her with being who she is.

Mielle is learning what it means to care for self and others, to organize her life, acquire skills and access her own dreams and those of her community. We work with KSCL administration to set goals, evaluate situations and create plans.

When we moved to Castlegar, the very accessible and helpful KSCL administrator, Karina Allis, encouraged me to seek a balance between home and public life and not to let fear-induced isolation outweigh inclusion in our new life here. I'm grateful she planted that seed of thought in me.

The parent of a child with special needs is vulnerable to how the world will treat their child. You don't want to be overly protective or hiding "safely" at home too much of the time, so you learn to adapt and modify those feelings in order to put yourself and other people at ease.

Let the love for your child and the world flow and let others see you are comfortable and not afraid. Then they might also become comfortable and unafraid.

Though Mielle is now 25 years old, I still practice "bridging" these worlds, and find that mostly people are fabulous to her and very open to her differences. Perhaps that is one of the benefits of living a simpler life in a small town.

KSCL is an invaluable resource that constantly expands our world of possibility.

Thank you, KSCL!

that is how basic and simple it is.

A Health Scare

In the fall of 2009 Mielle began attending the KSCL Adult Program three days a week with a one-on-one support worker. Expectations were higher for her to behave like an adult and this was quite stressful at first. Every time she heard the word "adult" she would protest loudly.

One day she seemed pale and low energy and was having a hard time recovering from a cold. She started wincing in pain and having difficulty breathing so we rushed her to Emergency in Nelson. We found out that many things were not right with her health: her oxygen saturation was low, she was bloated with excess water and her ovaries were enlarged. After a week in Kootenay Lake Hospital she was flown to Vancouver General for further testing.

Her Dad came to be with Mielle while I returned home for a root canal. My brother Kyle came from Castlegar to see her and drive me back to the Kootenays.

I was very grateful for his company and for family visits which helped keep our spirits up.

Mielle was sent to the PACH clinic at St. Paul's Hospital which specializes in heart conditions and I was worried there would be another surgery.

Finally, after three weeks of tests and experiments with various drugs, she was allowed to return home under the watchful eye of the cardiology team in Nelson, which included a temporary intern who suggested thyroid medication. This made a huge difference in stabilizing her health, reducing the size of her ovaries and regulating her hormones.

That's when I realized Mielle was having a physical as well as emotional adjustment to the demands of adulthood.

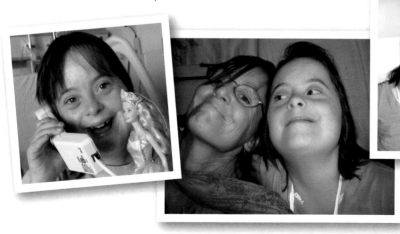

Uncle Kevin and cousin Anna

A favourite nurse

The love of family and caring nurses can make three weeks in hospital go a little easier.

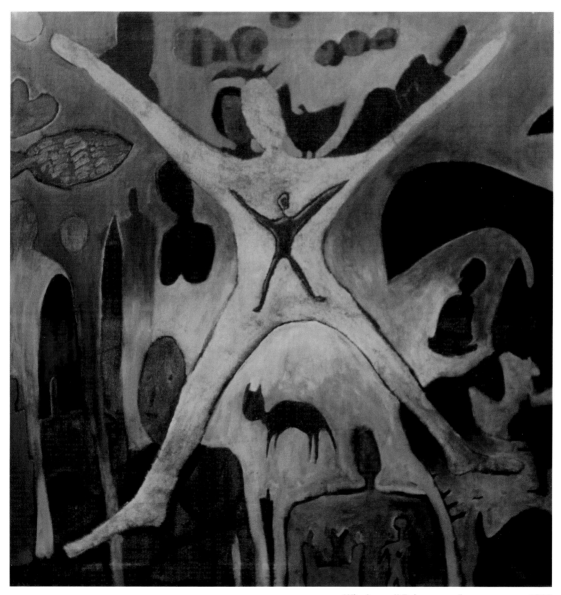

Whatever It Takes, acrylic on canvas, 1998

Sacred & Special Places

Do you have a place you go that's special to you or your family?
Somewhere that holds you and grounds you
whether you feel fantastic or contemplative,
sad or grateful?

For centuries, human beings have designated certain places as sacred or magical.
The earth can help us by just being there when we are in need.
I think trees, water, rocks and sky love being interwoven into our stories!

When Kyle came to Vancouver to visit Mielle in hospital,
he brought his guitar and gifts from Aunty Tammy
who suggested we go to The Hopi Circle at Jericho Beach.

I'd been to this sacred place many times
and welcomed her suggestion.

So while Grandma June kept Mielle company,
Kyle and I went to commune with the universe to please
allow my dear daughter to become healthy and strong again.

We played music, moved big logs into a teepee formation
and shared our hopes and wishes
with the elements of the earth.

Transformation

She saw me staring out
the window and probably
felt my worried and sad vibe
from where she was in her
hospital bed and she said,
"Mom….don't!" so I don't
and felt I had to take bravery
in from wherever I could find it.

And I am / she is / like ice or butter, a fragile
temperature-sensitive crystalline-like structure
that will hang in there in the right conditions.
So that is what has to be done…

TO GET INTO THE RIGHT CONDITION.

I could not close and shut down but had to open up and take in
like the camera that I like to be.
So I am remembering the empowerment of pilates and yoga
and now doing these things on the hospital floor and planning, focusing
and she and I are slowly moving somewhere with something.

We are also finding out about the lives of nurses
(my fave was Patty with the gold tooth)
and I am doing my best to help us not go crazy.

Our family is helping us too, and we are lucky
and damn all things not cooperating with the love that is at work here!

Trust the Universe, watercolour, 2013

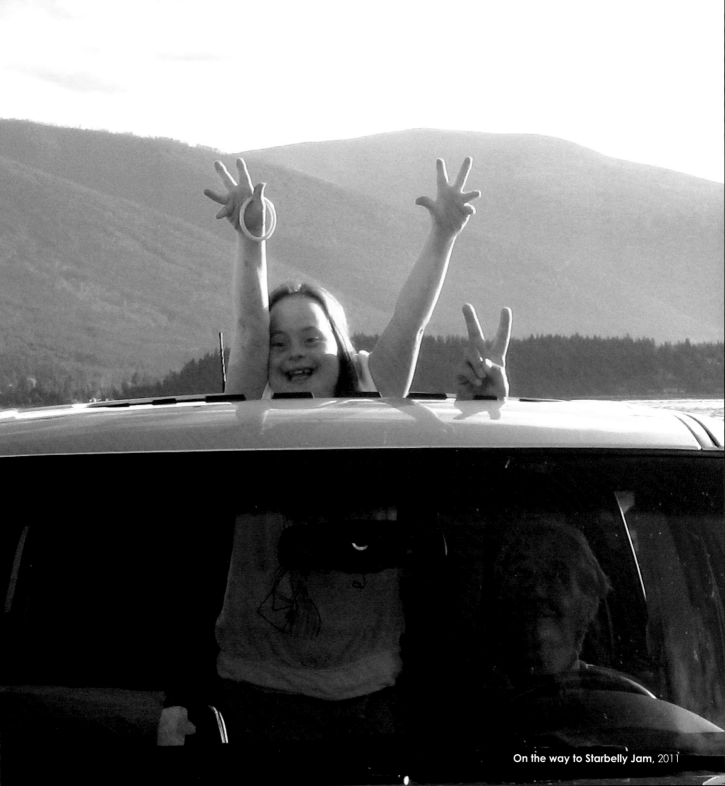

On the way to Starbelly Jam, 2011

Starbelly Jam

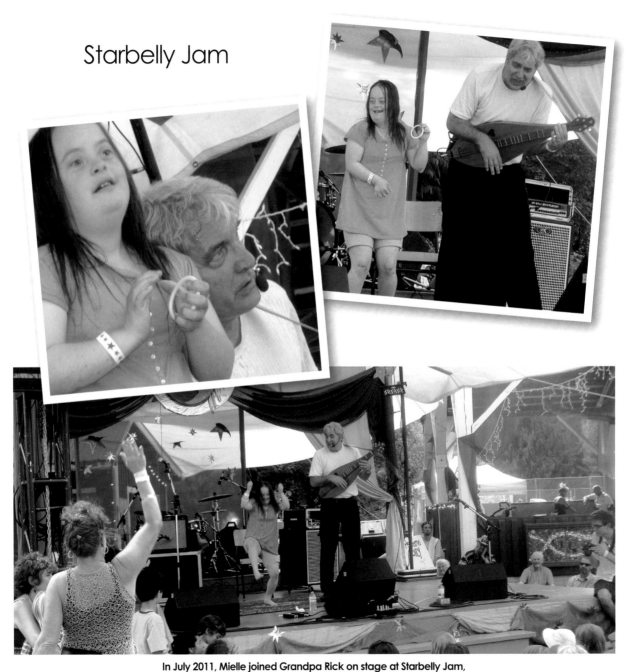

In July 2011, Mielle joined Grandpa Rick on stage at Starbelly Jam,
a family-friendly community music festival in the scenic hamlet of Crawford Bay, BC.

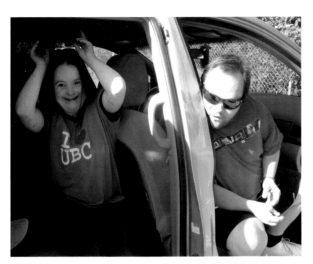

Mielle and Dustin prepare for a road trip to Victoria for Operation Trackshoes, 2015

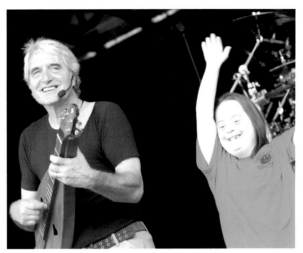

Rick and Mielle perform together at Special Woodstock, 2012

Photo by Peter Rusland, Cowichan News Leader Pictorial

Operation Trackshoes

Every year Mielle looks forward to Operation Trackshoes, a sports festival for BC residents with developmental disabilities, held at the University of Victoria each June.

Over three years she's earned a stack of ribbons which she proudly displays in her room and can't wait to show to Dad!

She loves the opening ceremonies, recreational and competitive events, banquet and dance, and particularly enjoys the sleepovers in the dormitories at UVic.

Presented by the Province of BC and many generous sponsors and volunteers, Operation Trackshoes celebrated its 45th anniversary in 2015.

Special Woodstock

A remarkable gathering takes place every August at beautiful Providence Farm outside Duncan on Vancouver Island: a unique music festival for people of all ages and abilities and their caregivers, families and friends.

Professional musicians donate their services to accompany a wide range of artists both abled and alter-abled.

The day is filled with joy made audible, radiant smiles and spirited community gathered to play, sing, dance and exuberantly celebrate differences.

Special Woodstock emerged from the vision of Shelley Smiley Vaags and for 16 years has been run entirely by volunteers.

The finale of 2013 Bluegrass Festival in Castlegar

Dancing Queen of my heart!

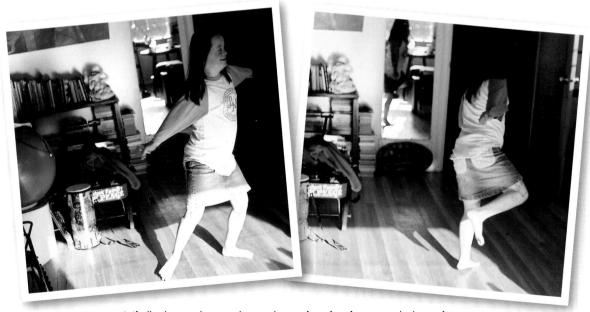

Mielle has always loved music, singing and dancing.
Sometimes I'll hear her sing for two hours to music she's playing in her room.
That is some serious practice! She says she wants to be in a girl band.

Special Olympics and Physical Fun

Before research revealed the physical and genetic impact of Down syndrome, health challenges and weight problems often resulted in death at an early age.

Now we understand the importance of physical activity, diet and social interaction for longevity and quality of life.

Because of its artificial valve, Mielle's heart will always be a concern. The importance of her daily health habits cannot be understated. We eat as much unprocessed food as possible. She swims, walks and gets lots of fresh air and exercise.

Participating in rhythmic gymnastics and bowling as a Special Olympics athlete has been great for her physical and social engagement.

The emphasis is on participation more than competition, creating a welcoming environment for learning about listening skills and group participation.

Trying anything new and unfamiliar is always a hurdle for Mielle. Sometimes change happens at a glacial pace. When she started bowling two years ago she was queen of the gutter ball. Now she scores strikes and spares!

Three years ago she was reluctant about gymnastics practice but now she willingly participates in both solo and unified movement.

She's gained a real sense of accomplishment and heightened social skills and I have a great time too as a volunteer coach.

Castlegar hosted its first Special Olympics Rhythmic Gymnastics Competition in March 2015.

Rhythmic Gymnastics, 2015

Horseback Riding

In 2014, Mielle received a CLBC Recreational Scholarship for horseback riding. My father had two horses so I knew she wasn't afraid of this big animal. Phil Morris and Jessica Owen at Walking Tree Ranch in Robson needed no persuasion to take her on as a rider-in-training.

Off she went on this awesome horse adventure, 10 lessons twice a week. Phil said, "People with Down syndrome start with love, don't they?"

Riding enhances physical, emotional and social skills while promoting strength, balance, coordination and confidence. Phil and Jessica partner with horses and dogs for therapeutic learning and progressive development of body, mind and spirit.

They were great with Mielle and with me, the overly protective Mumzy. They asked me how to go about being with Mielle and provided feedback after every lesson. The learning environment was relaxed and it was a great achievement to get Level 1 Horseback Riding under her belt.

Mielle proudly receives her Level 1 certificate from Phil and Jessica

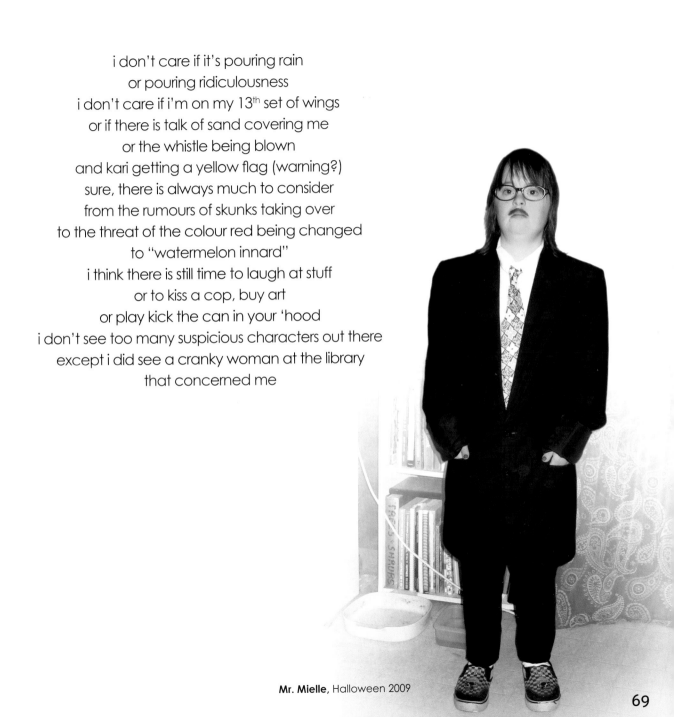

i don't care if it's pouring rain
or pouring ridiculousness
i don't care if i'm on my 13th set of wings
or if there is talk of sand covering me
or the whistle being blown
and kari getting a yellow flag (warning?)
sure, there is always much to consider
from the rumours of skunks taking over
to the threat of the colour red being changed
to "watermelon innard"
i think there is still time to laugh at stuff
or to kiss a cop, buy art
or play kick the can in your 'hood
i don't see too many suspicious characters out there
except i did see a cranky woman at the library
that concerned me

Mr. Mielle, Halloween 2009

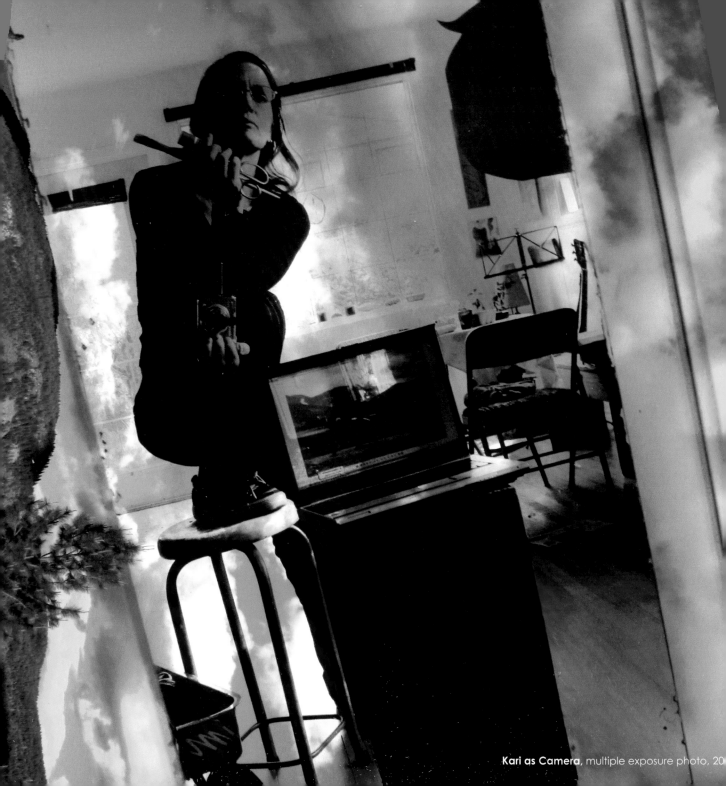

Kari as Camera, multiple exposure photo, 20

Art

"... being so much greater than ourselves,
it will not give up once it has taken hold."

Emily Carr

Self-portrait, MS Paint, 2015

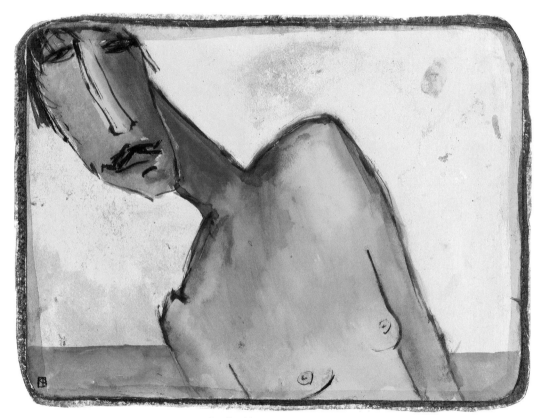

Radical in the Wind, watercolour on handmade paper, 1997

Art Is My Mother Tongue

I think of art as my mother tongue and a place where I can commune with the universe. It's like doing magic because suddenly something appears, and from where?

I started to do art for other people in Grade three. We were making Father's Day cards in class and a boy sitting next to me asked if I could draw a man with a suit and tie on his card like I had drawn on mine.

In my youth my girlfriends would sometimes get annoyed and say, "All she wants to do is take pictures!" I used to make drawings with full intention of making my school friends laugh but sometimes this would backfire and I was handed a detention for disrupting the class.

Even when I had children of my own, I was still doing drawings with the same intention. I like to honour the creative process by giving it plenty of time and space to become whatever it is that it's going to be.

When I graduated from Emily Carr School of Art in 1986, a columnist from the *Vancouver Sun* wrote, "Kari Burk's anarchistic spirit shines through her line drawings" which was a bit of a shocker because I didn't think of myself as anarchistic.

But the description eventually grew on me and perhaps was even the seed that gave me the feeling that it was okay to do weird drawings.

My creative nature has turned out to be advantageous with Mielle because she's a visual learner so I can use drawings to help her understand homework, sequential tasks and schedules.

My artistic sensibilities are put to good use in how I interact with her and how we unfold our lives together.

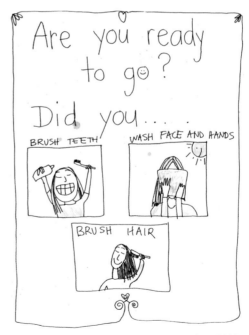

Sequence mapping, 2000

73

Fwap!

"Mom! ... Fwap!"
Sometimes the Mom did not know what this child was saying.
When the child sang "dodododododdooooooo!"
the mom loved that singing and clapped her hands!

Sometimes the child was wandering around the house
with a bare bum, red boots and a smile.

If there was some new art on the wall
you could be sure this child
would notice it and say
"Hey… nice, Mom!"

From the 1995 poetry book *like over-wintering-purple-sprouting-broccoli*

drawing in and
drawing out

it's about
learning to like
pink because
she likes pink

I am here and
there for her

Pink, MS Microsoft Paint doodle, 2011

plant mad cap tree, collage by P'Chi and Kari, 1994

plant mad cap tree

Grandma P'Chi and I
love to make collages.

We made this one when Mielle
was in hospital.

P'Chi cut the pieces
and I glued them in place.

Collage is a quick easy way
to have fun, express yourself
and create an artistic snapshot
of self in time and place.

P'Chi's cousin,
Audrey Von Hawley,
established the
Sonoma Collage Studio in 1994.

One of its students,
Lindsay Whiting,
created a beautiful book:

*Living Into Art –
Journeys Through Collage.*

Mielle's Clipboard

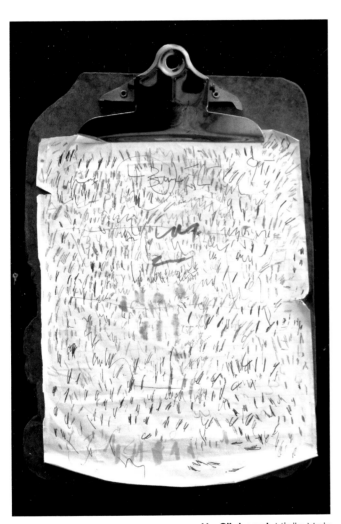

My Clipboard, Mielle Metz

This clipboard with this piece of paper on it can always be found somewhere in Mielle's room. I've asked if she would like a new piece of paper but she doesn't seem to want one.

Every now and again a new mark gets added on the paper. I would love to know what all those marks mean but she doesn't seem to want to tell me.

Mielle loves looking at magazines, books and advertising. She can identify letters, quite a few words, days of the week and names. She's simply not a typical reader and writer.

Many people with Down syndrome are excellent readers and writers. Just like everyone else, alter-abled people have abilities and capabilities in varying degrees.

At first I found it hard to accept that even after years and years of instruction she does not fully have these skills, but then I said to myself that she has many other things to offer the universe so let's shine those things.

Sometimes there's a winter storm in my heart
that I need to wait out

Winter Storm, watercolour, 2012

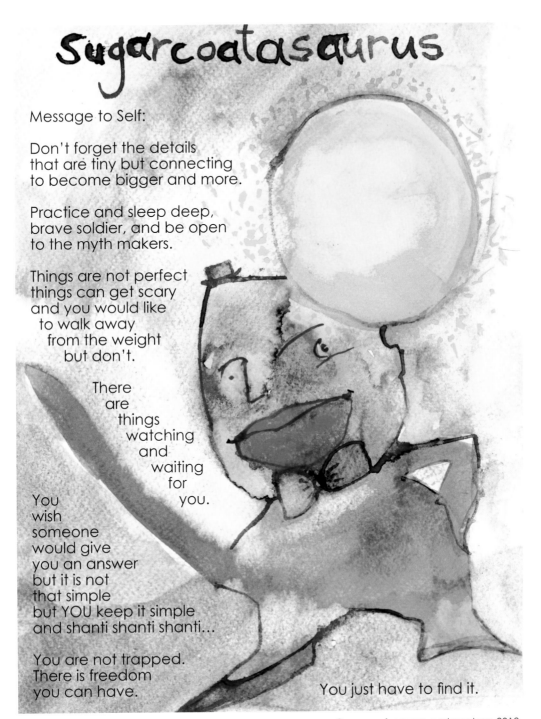

Sugarcoatasaurus

Message to Self:

Don't forget the details
that are tiny but connecting
to become bigger and more.

Practice and sleep deep,
brave soldier, and be open
to the myth makers.

Things are not perfect
things can get scary
and you would like
 to walk away
 from the weight
 but don't.

 There
 are
 things
 watching
 and
 waiting
 for
 you.

You
wish
someone
would give
you an answer
but it is not
that simple
but YOU keep it simple
and shanti shanti shanti...

You are not trapped.
There is freedom
you can have.

You just have to find it.

Drawing cartoons can lighten the weight of the world!

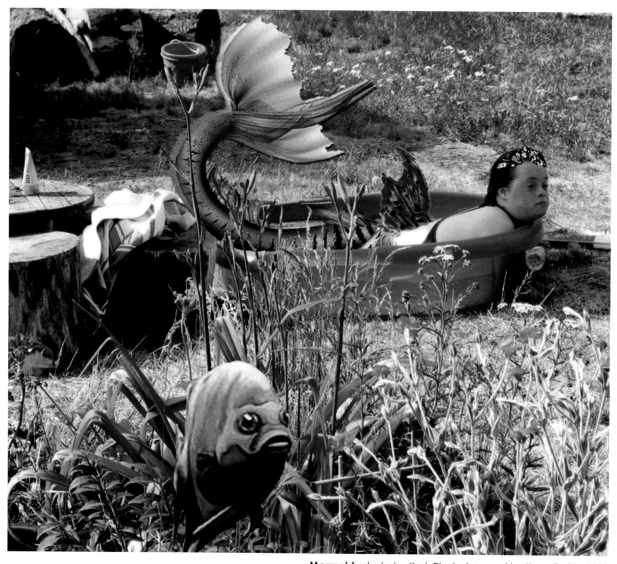

Mermaid, photo by Kari, Photoshopped by Kerry Smith, 2009

Change Like the Weather, acrylic on door skin, 2010

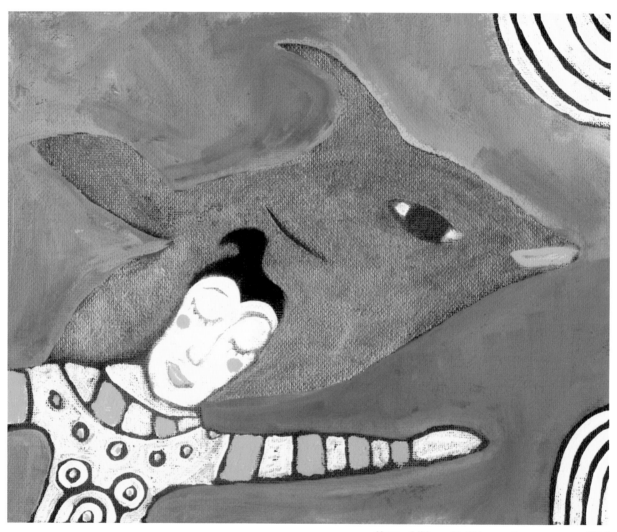

Shapeshifting with Fish, acrylic on canvas, 2015

A.C.E. in the Whole

Being a parent of an alter-abled person can be very challenging. Something that helps me is a technique I call my "A.C.E. in the whole."

I was inspired by cyber-scientist Steve Chen and his work on what he calls the "third brain" or "supercomputer." He says, "The good thing about human beings is that we continue to adapt, create and evolve."

Those three words became a golden key to me, along with the realization that sources of inspiration and success can be found in unexpected places.

Three-time heavyweight champion Mohammed Ali succeeded by doing the opposite of what was expected of him: he avoided throwing and receiving punches, using fancy footwork until his opponent was exhausted.

Antonio Gaudi used curves, colours and broken dishes in wildly imaginative architecture that gave us the word "gaudy" and is widely admired for its innovative genius.

Socrates said that the greatest way to live with honour is to be what we pretend to be. Dr. Deepak Chopra says what we seek we already are.

So perhaps we don't need to look too far for guidance or help. Maybe it's already within our own self, or maybe it's in a conversation with a friend or neighbour.

The important thing is to be open to learn and try to find the tools that build our lives. Things seldom happen according to plan.

Adapt, Create and Evolve. That's my A.C.E. in the whole.

Mielle and Her Satellites, watercolour, 2013

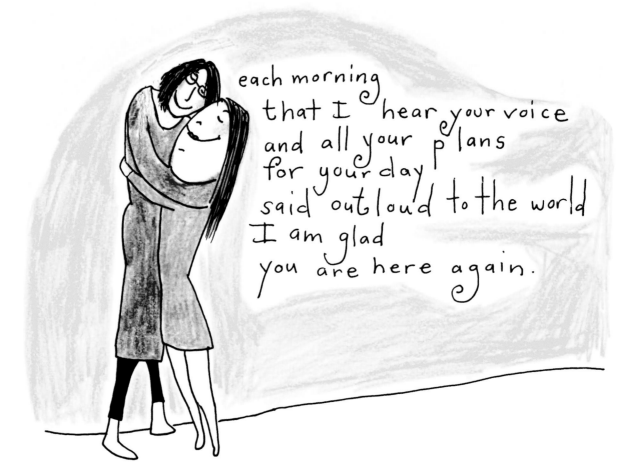

each morning
that I hear your voice
and all your plans
for your day
said out loud to the world
I am glad
you are here again.

Each morning, ink and pencil crayon, 2015

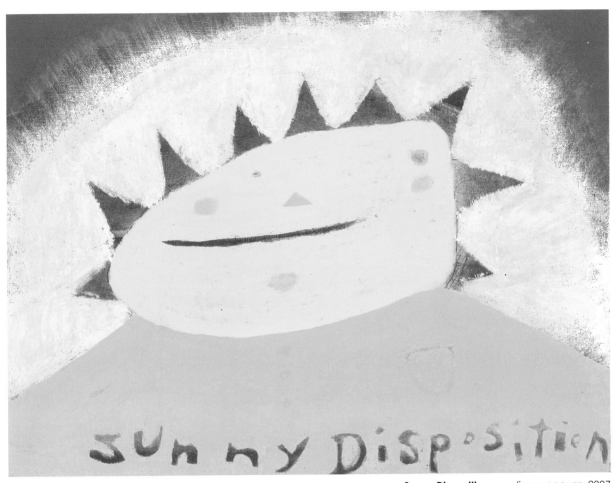

Sunny Disposition, acrylic on canvas, 2007

For me, the line is fine and almost indiscernible as to what is my life
and what is Mielle's. What is clear to me though is that
I acknowledge the positive aspects of this entwinement:
that the adjustments and accommodations
can benefit me as person and artist.

give us time
and we will explain
give us a hand
and we will build
give us love
and we will share
give us light
and we will shine

Mielle with pals Rachel Gutwald & Heather Cook at Castlegar Downtown Artfarm, 2013

Photo by Liz Sali

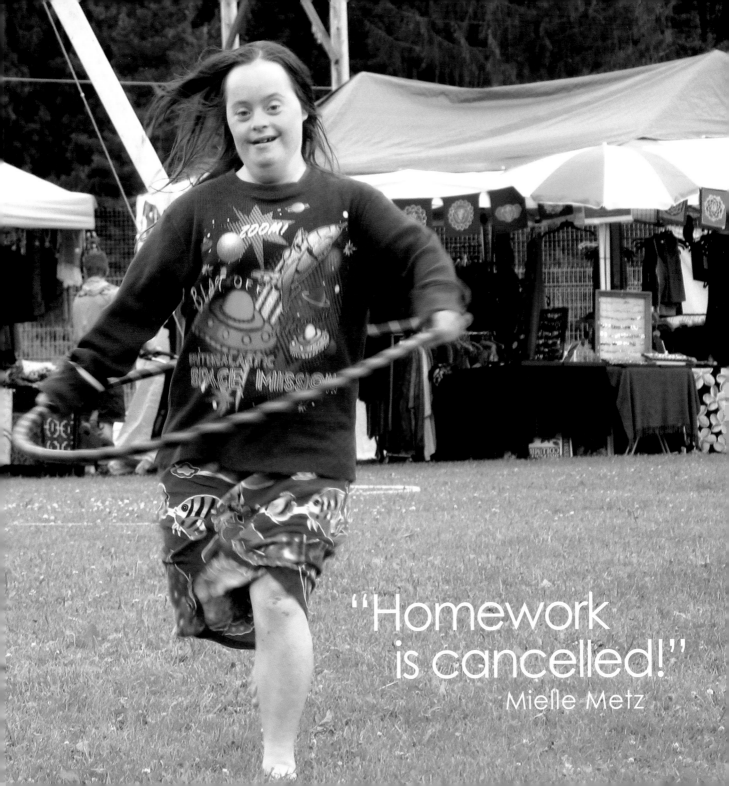

"Homework
is cancelled!"
Mielle Metz

Kari's Recommended Reading, Listening & Viewing

Books and Magazines
- *Community and Growth* and *Becoming Human* by Jean Vanier
- *Living Into Art: Journeys Through Collage* by Lindsay Whiting (Paper Lantern Press)
- *Olly Takes Fiddle to the Hospital* by Phyllis Lysionek – anxiety & fear of the medical world
- *Our Brother Has Down Syndrome* by Shelley Cairo – sisters write about life with Down syndrome
- *Sacred Ground to Sacred Space: Visionary Ecology, Perennial Wisdom, Environmental Ritual and Art* by Rowena Pattée Kryder
- *The Gift of Martha* by Clare D. Canning – family life with a daughter with Down syndrome
- *The Power of Knowing Each Other* by Community Living BC – informal safeguards in BC
- *Voices* magazine by and for people with Down syndrome www.cdss.ca/voices-magazine.html
- *Writing with Grace: A Journey Beyond Down Syndrome* by Judy McFarlane
- Woodbine House offers books about disabilities www.woodbinehouse.com

Audio & Video www.rickscott.ca/videos
- "Angels Do" – music video featuring Mielle and Rick Scott, from the CD *Philharmonic Fool*
- "Upside of Down" – music video by Pied Pumkin, Fred Penner and performing artists with Down syndrome at the 2006 World Congress on Down Syndrome, from the CD *Pumkids*

Organizations
- Down Syndrome Research Foundation (DSRF) www.dsrf.org
- Canadian Down Syndrome Society (CDSS) www.cdss.ca
- Down Syndrome International (DSI) www.ds-int.org
- Community Living BC (CLBC) www.communitylivingbc.ca
- Kootenay Society for Community Living (KSCL) www.ksclcastlegar.net

Websites
- Band of Angels – non-medical information and support www.bandofangels.com
- Circle 21 – social entrepreneurs for global change www.circle21.com
- Exploring social issues through movement www.dandeliondancecompany.ca
- Human rights should never be disabled www.teresapocock.com
- Inclusive Leadership www.inclusiveleadershipco-op.org
- Operation Trackshoes www.trackshoes.ca
- Special Woodstock www.specialwoodstock.ca
- World Down Syndrome Day www.worlddownsyndromeday.org

About the Authors

Kari Burk

Author and illustrator Kari Burk is a multimedia artist and landscape gardener who operates Muddy Tutu, Organized Grime and Garden Art in Castlegar, BC. A graduate of Emily Carr School of Art and Design. She's a painter, poet, performance artist, musician, dancer, cartoonist and curator. She has self-published 14 chapbooks of poetry and exhibited and performed throughout BC. Her art is available for sale and by commission. Kari lives on a Kootenay mountaintop with one of her greatest works of art, her daughter Mielle.

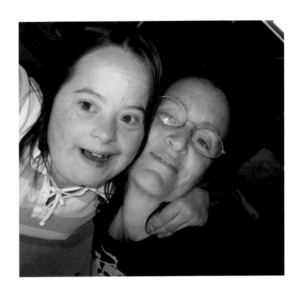

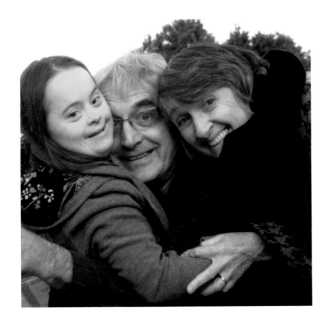

Valerie Hennell

Writer, producer, publisher and poet, Valerie Hennell conjures projects for page, stage, CD and media. She has a Master's degree in Creative Writing from the University of British Columbia where she launched a career that has spanned 50 years and 10 countries. Her lyrics are sung by many; her recordings have been honoured with four Juno nominations, Parents' Choice, NAPPA Gold and Canadian Folk Music Awards. Enthusiastic grandmother, kayaker and composter, Valley lives on Protection Island in the Salish Sea with her husband and long-time partner in life and art, musician Rick Scott.

Thank You

To friends and family
& everyone mentioned
& pictured in this book
for your generous
contribution to our lives.

Katrina & Eileen at Kel-Print
Down Syndrome Research Foundation
Kootenay Society for Community Living
Gerhard & our friends at Friesens
Callaghan Photography
Kootenay Art Gallery
Anne Champagne
Castlegar Library

Max for support
Ronan Lannuzel for design
Valley & Rick for everything

Columbia Basin Trust /
Columbia Kootenay Cultural Alliance
& our Indiegogo supporters
for funding assistance

Order a print from this book
Commission or purchase a painting, drawing,
greeting card or cartoon:
burkyworld@gmail.com

Many People, watercolour, 2013

www.snapshotofasoulplace.com